IMAGES
of Modern America

GALVESTON'S TREE CARVINGS

On the Front Cover: Clockwise from top left:
The Birds of Galveston by Dayle Lewis (Author's collection; see page 34), the floodwaters of Hurricane Ike (Author's collection; see pages 94–95), *Pod of Dolphins and Mermaid* by Earl Jones (Author's collection; see page 85), *Jack Johnson* by Earl Jones (Author's collection; see page 81), *Blue Herons* by Earl Jones (Author's collection; see page 67).

On the Back Cover: From left to right:
Grandmother Reading to Her Grandchildren by Earl Jones (Author's collection; see page 90), Crane, *Pelican Diving into a School of Fish* by Jim Phillips (Author's collection; see page 45), *Pelicans* by Dayle Lewis (Author's collection; see page 30).

IMAGES
of Modern America

GALVESTON'S TREE CARVINGS

[signature]

Joseph R. Pellerin

ARCADIA
PUBLISHING

Copyright © 2015 by Joseph R. Pellerin
ISBN 978-1-4671-3305-0

Published by Arcadia Publishing
Charleston, South Carolina

Printed in the United States of America

Library of Congress Control Number: 2014957780

For all general information, please contact Arcadia Publishing:
Telephone 843-853-2070
Fax 843-853-0044
E-mail sales@arcadiapublishing.com
For customer service and orders:
Toll-Free 1-888-313-2665

Visit us on the Internet at www.arcadiapublishing.com

This book is dedicated to my parents, Joe and Rita Pellerin, and the people of Galveston, who will always stay and rebuild.

Contents

Acknowledgments 6

Introduction 7

1. A City in Ruins 9
2. Carvings by Dale Lewis 17
3. Carvings by Jim Phillips 37
4. Carvings by Earl Jones 59

Acknowledgments

The author acknowledges and thanks Arcadia Publishing for making this book possible. Also, Donna Leibbert for suggesting the carvings, the homeowners for commissioning them, the artists Dayle Lewis, Jim Phillips, and Earl Jones for carving them, and the Galveston Island Tree Conservancy (GITC) for planting more than 8,000 trees since Hurricane Ike through its Re-Green Galveston program.

For more information on the GITC's replanting efforts, visit www.galvestonislandtreeconservancy.org. Donations for future carvings or the replanting of trees can be mailed to:

GITC
PO Box 2123
Galveston, TX 77553
Please specify if the donation is to be used for carvings or replanting.

Unless otherwise noted, all images appear courtesy of the author.

INTRODUCTION

My name is Joseph Pellerin, and I am a third-generation Galvestonian, or, as we say in Galveston, a BOI (born on the island). I teach American history part time at San Jacinto College in Pasadena, Texas, but I operate a sightseeing tour business, Galveston Historic Tour, as my full-time job. The tree carvings are included on my tour, and several of my guests asked me if there was a book on them. When I mentioned there was not, they suggested there should be. I thought that was great idea, so here we are. First, some background on the area is needed. Galveston is a sand barrier island that nature created to protect the Texas Gulf Coast from hurricanes. However, as it was the deepest natural harbor in the state, Michel Menard thought it a great place to establish a city. The city of Galveston was chartered in 1839. Being a sand barrier island, Galveston has had its fair share of hurricanes, with the worst occurring in 1900, known locally as the Great Storm or Great Hurricane of 1900. To date, it remains the worst natural disaster in the history of the United States, and an estimated 6,000 people were killed in Galveston alone. Following the disaster, many people stayed and helped rebuild the city, and two improvements were made. One was the addition of a 17-foot-high, 3-mile-long seawall along the gulf side of the island. After three extensions, the current seawall is roughly 10 miles long. The second improvement was the grade raising. The city dredged Galveston Bay and filled in the city. The grade raising begins at the seawall, matching its height at 17 feet. There is then a gradual slope down that runs south to north. Since the construction of the seawall, hurricane storm surges coming from the gulf have been thwarted by the seawall. However, with nothing to protect the bay side, the flooding has come from there. This what happened during every hurricane since 1900, including the 1915 hurricane, Hurricane Carla in 1961, Hurricane Alicia in 1983, and Hurricane Ike in 2008, which brings us to the tree carvings.

The Saffir-Simpson wind scale measures the strength of hurricanes based on their wind speed on a scale of one to five, with five being the strongest. Hurricane Ike in 2008 was a Category 2 with 110-mile-per-hour sustained winds. However, it brought with it a massive storm surge of 12 feet. This was well above average for a Category 2 hurricane. Just as with every hurricane since 1915, the seawall stopped the surge from the Gulf of Mexico, but there was nothing to stop it from Galveston Bay. As a result, downtown Galveston, also known as the Strand District, got the worst flooding (roughly eight feet). The water level then decreased as it approached the seawall since the island becomes higher when traveling that direction, so the water level was only around six inches right behind the seawall. When it comes to saltwater, though, six inches is a bad as six feet. Because of the massive size of Ike, flooding began about 14 hours before the eye of the hurricane made landfall. From the time Ike arrived to the time it left, most of Galveston's trees were sitting in saltwater for over 24 hours. Many of the trees, especially the oaks, could not tolerate of any amount of salt. After this saltwater bath, between 40,000 and 50,000 trees died where they stood. A large number of the oak trees were over 100 years old.

The trees were evaluated by the Texas Forest Service and the US Forest Service. By the spring of 2009, it was clear the trees were not coming back. Once a tree was determined to be dead, it was sprayed-painted with an orange X by the city and later cut down. Much of the wood was turned into lumber or furniture or was sold to artists to be turned into wood carvings. Some of the oak made its way to the Mystic Seaport Museum in Connecticut, where it was used to restore the frame of the *Charles W. Morgan*, America's only surviving wooden whale ship. However, the loss of the trees added to the devastation suffered by Galveston's citizens following Ike. Donna Leibbert, a member of the Galveston Island Tree Conservancy, travelled to Biloxi, Mississippi, and saw trees killed by Hurricane Katrina turned into carvings. Inspired, Donna proposed the same idea for Galveston's dead trees to the city council. Once liability issues were resolved, the city allowed trees on easements to be carved, and it even commissioned two carvings for city hall next to the Central Fire Station and one carving each in four of the city parks. Houston artist Jim Phillips completed the first two carvings (a fire hydrant and a Dalmatian) in August 2009. Soon, the idea caught on, and new carvings started to pop up all over town. In fact, there are still stumps being carved. Jim Phillips carved the latest addition in February 2014.

One

THE CITY IN RUINS

Although Galveston lies in the path of many hurricanes, the resiliency of its citizens never ceases to amaze. Through the greatest natural disaster in America's history and numerous hurricanes and tropical storms, the citizens of Galveston have always stayed and rebuilt. Indianola, Texas, was a prosperous port city of more than 5,000 residents when a major hurricane in 1875 devastated the community. The citizens rebuilt the town on a smaller scale; however, it was promptly obliterated by a second major hurricane on August 20, 1886. After the second storm, the city was abandoned. The Great Hurricane of 1900 could have caused Galveston to go the way of Indianola, but it did not. The Great Storm is known by various names, as it occurred before the current tropical storm naming system was established by the National Weather Service. It is still recognized as the deadliest natural disaster in US history, with an estimated death toll of 6,000 people. The roads and bridges were completely demolished, leaving no opportunity for evacuation or rescue in the days to follow. The city was not only rebuilt, it was rebuilt with hurricane defenses. Galveston then redefined itself as the "Playground of the Southwest," becoming a tourist destination. The city and its residents went on to survive a more powerful hurricane in 1915, the Category 4 Hurricane Carla in 1961, the Category 3 Hurricane Alicia in 1983, and the Category 2 Hurricane Ike in 2008. Hurricane Ike, much like the Great Hurricane of 1900, was a notable storm. While only clocking in as a Category 2 hurricane with 110-mile-per-hour winds, it was a massive storm. Gale-force winds reached 275 miles away from the eye, and hurricane-force winds extended out 120 miles from the eye. The eye at one time was 60 miles across and then shrank to 30 miles across as it made landfall. The huge wind field caused Ike's storm surge. The sheer size of Ike and its high winds allowed it to push an immense amount of water into the coast of Texas. In fact, it pushed a larger amount of water than a normal-sized Category 2 hurricane would have. This was a Texas-sized storm, though. A storm surge of between 10 and 20 feet ripped through areas surrounding Galveston Bay, and the flooding knocked out water service, electricity, and roadways in Galveston for weeks after the storm. Hurricane Ike ranks as the third-costliest hurricane in American history—behind Hurricanes Katrina (2005) and Sandy (2012)—with over $30 billion in damage. However, despite the devastation, the citizens of Galveston once again came together to rebuild, and even improve, their city. As a phoenix rises from the ashes, some of the trees killed by Hurricane Ike's massive saltwater storm surge rose from mere stumps to beautiful works of art that are now a major tourist attraction.

Lucas Terrace, located at Broadway and Sixth Street, was an apartment building. This is all that was left of 64 apartments after the Great Hurricane of 1900. While as many as 80 people were buried in the rumble, 23 survived the hurricane, 22 of them in the lone standing apartment. (Courtesy of Library of Congress, Prints & Photographs Division.)

A path is being cleared through the debris in this view looking north down Nineteenth Street. (Courtesy of Library of Congress, Prints & Photographs Division.)

This is a photograph of the dead being gathered and placed on wagons after the Great Storm of 1900. At first, the bodies were buried at sea, but when they washed back onto the beach, they were cremated. (Courtesy of Library of Congress, Prints & Photographs Division.)

A 17-foot-high seawall was built following the Great Hurricane of 1900. The first three-mile-long section was constructed between 1902 and 1904. Today, the seawall is 10 miles long. The grade of Galveston was also raised, starting at 17 feet at the seawall and gradually sloping back down toward the bay. The grade raising lasted from 1903 through 1911. (Both, courtesy of Library of Congress Prints and Photographs Division.)

This is what was left standing of a public school located at Twenty-fifth Street after the Great Hurricane of 1900. (Courtesy of Library of Congress, Prints & Photographs Division.)

Shown here is the aftermath of Hurricane Ike in 2008. This photograph was taken at Twenty-third Street looking east down Post Office Avenue.

A shrimp boats sits in the parking lot of Willie G's restaurant at Pier 21 following Hurricane Ike.

The Flagship Hotel was severely damaged by Hurricane Ike. The Pleasure Pier, built following World War II and featuring several amusements, originally stood here. Hurricane Carla in 1961 destroyed the Pleasure Pier, and the Flagship Hotel was constructed in its place. Following Ike, Tillman Fertitta, who owns the Landry's Corp., bought the hotel, tore it down, and replaced it with a modern version of the Pleasure Pier.

Murdoch's Bathhouse used to be an actual bathhouse. Today, it is a souvenir shop. Murdoch's has been destroyed in almost every major Galveston hurricane, and it has been rebuilt every time, including after Ike. Seen below are both Murdoch's Bathhouse and the Flagship Hotel after Ike.

Here is a look at the damage done on the bay side of the island. Pictured is the back of Fisherman's Wharf restaurant at Pier 22. All the damage seen has since been rebuilt.

Dead oak trees lined Broadway following Hurricane Ike. Many were planted after the 1900 Hurricane, and some were planted after World War I, making most of them between 90 and 108 years old.

Two

Carvings by Dayle Lewis

Dayle Lewis grew up on a dairy farm in Pratt, Kansas, and earned a degree in industrial engineering at Kansas State University. He began making wood carvings in 1992 and has since become an award-winning wood-carving artist. Dayle is mostly self-taught, having learned the craft through books, trial and error, and watching other artists. He began carving with a chainsaw in December 1996. Chainsaw carving is incredibly different than hand carving; however, Dayle's experience as a hand carver proved an advantage in becoming a skilled chainsaw carver. One of his passions is walking into someone's yard and creating a sculpture from a tree stump. Although he has carved just about every wood imaginable, Dayle's favorite to work with is catalpa. His primarily carving tools are Husqvarna chainsaws of different sizes. He also enjoys sharing his love of carving with others, and in February 1998, he began teaching hand-carving classes at Hayes Arboretum in Richmond, Indiana. Traveling to various cities and states, he has taught more than 1,600 people aged 8 to 88 the art of wood carving. Dayle entered his first carving contest in 2000 in Converse, Indiana, where he placed third with a carving of a large rabbit with a baby rabbit sitting between its ears. He won first place the next year in the same contest with a bowlegged cowboy. Dayle started carving full time in 2002, doing about half hand carving and half chainsaw carving. He also wrote a carving how-to book in 2003. In February 2006, he traveled to New Orleans and assisted in the KatRita Wood Project. He spent roughly three weeks carving hurricane-damaged logs and transforming them into sculptures that were then sold for the relief fund. Dayle returned to the area and helped out with carvings in Mississippi and Louisiana. He then arrived in Galveston in 2010 to carve some of the trees killed by Hurricane Ike. Dayle still enters carving contests. He won third place in a contest in Missouri, and in Michigan contests, he won third place in 2008, second place in 2011 and 2012, and first place in 2009 and 2014. Today, the vast majority of Dayle's carving is done by chainsaw. He currently produces around 325 carvings per year and does commission work in various states. Dayle says, "It's very relaxing and really enjoyable to create something from an idea or picture. It's a real joy to show them the final product and see their face light up!" Dayle's carvings can be viewed on chainsawsculptors.com and on Facebook (Dayle Keith Lewis).

This toad carving is located at 1615 Ball Avenue. Toads are numerous in Galveston, and the Texas toad, one of the most abundant toads in the state, is also the official state amphibian of Texas. Gov. Rick Perry designated it as such when he signed House Concurrent Resolution No. 18 on June 19, 2009.

The *Yellow Lab* is located at 1820 Winnie Avenue. When Dayle first carved the lab, the homeowners found a concrete basket of puppies and displayed them next to the carving. The old homeowners have since moved out, and this image shows what the lab looks like today.

The *Wildlife Tree* in Schreiber Flagship Park is located on Eighty-third Street near the municipal baseball fields. This is one of the four parks for which the city commissioned a carving. The Schreiber Flagship Park was specially designed by park architects Leathers & Associates in 1996. Their park designs embrace a community-built idea that incorporates the surrounding history of the designated park area. Galvestonians Rhonda Gregg and Sheila Zwischenberger discovered the architect's designs while in San Marcos, Texas. From there, they spearheaded the organization, fundraising, and community involvement that it takes to build one of the Leathers & Associates designs.

The tree-shaped carving is inside the castle playground at the park. In this sculpture, Dayle carved a raccoon peeking out of the tree along with a dragonfly. These are two common animals that are native to Galveston.

In the above view of the *Wildlife Tree* at Schreiber Flagship Park, a squirrel sits on a branch at the top of the carving, and a snake slithers past. In the image below, the raccoon, snake, owl, and squirrel are all visible.

The *Great Dane* is located at 1228 Sealy Avenue. This carving is modeled after the homeowner's beloved Great Dane, Hunter. As result, the carving is nicknamed "Hunter." The tree grew around the fence, allowing Dayle to carve Hunter's paws gripping the fence. This is also the only carving to be vandalized; a vandal cut off one of Hunter's paws. In typical Galveston fashion, the homeowners put a bandage on the paw with a sign that read, "Five dollar reward for my paw. Five hundred dollar reward for the paw of the thief." The thief and the paw are still at large. However, Dayle was able to create a replacement paw for Hunter. Seen here is the artist at work.

Like some of the other carvings, these homeowners decorate for the holidays and Galveston events. The sculpture of Hunter wears many costumes throughout the year. On a sad note, the real Hunter, seen here, entered doggy heaven in early 2014.

The *Squirrel*, located at 1302 Ball Avenue, is one of the only few freestanding carvings. Many squirrels call the surviving oak trees home, and of course, a squirrel's favorite snack is an acorn. Therefore, the homeowners had their squirrel carved holding an acorn.

The home located at 1303 Ball Avenue has several sculptures that were commissioned in remembrance of trees lost because of Hurricane Ike. At left is the *Wildlife Totem Pole*, which has a heron (shown), a wolf, a turtle, a seagull, and an armadillo carved into what was left of this tree. Below is the *Owl* sculpture.

The *Dolphin, Dorado, and Eel* is located at 1302 Ball Avenue. The homeowners built their back deck around their oak tree, and after Ike killed it, they had this carving commissioned. Since the oak no longer shades the deck, the homeowners put up umbrellas. It is also worth noting that the eel is a moray, and dorado fish are also known as dolphin fish or mahimahi.

The *Great Blue Herons* is located at 1316 Ball Avenue. Since herons are tall, narrow birds, the homeowners chose them as the subject of their carving to mimic their tall, narrow house. Great blue herons are also a common sight around Galveston and can be found along the coast or in marshy areas.

The *Angels* is located at 1717 Ball Avenue. This is another freestanding carving, and it is located at the home of Donna Leibbert, who first suggested the idea for the carvings. Donna lost the oak tree in front of her house, and this sculpture is carved from a piece that came from the top of the tree when it was cut down. The angels represent her two granddaughters, and there is also a heron.

Three Pelicans and a Fish is located at 628 Fourteenth Street. These carvings are in the parking lot of local Galveston restaurant Mosquito Café. A close-up view shows there is a fish in the pelican's mouth.

Here are two other views of the pelicans sitting on their pilings. Pelicans are a common theme in the carvings, as the large birds are found all over the island.

The *Pelican on a Piling* is located at 1618 Church Avenue. Visitors to Galveston do not have to go far to see pelicans sitting on pilings, as they are in abundance along the harbor.

Here is an image of the same carving in 2014. It is usually decked in the holiday spirit, wearing Mardi Gras beads or, in this case, red, white, and blue leis for the Fourth of July.

The *Mermaid Holding a Clam Shell* is located at 1428 Church Avenue at a home that survived the Great Hurricane of 1900. The house was built by sea captain Rufus Jameson, in whose honor the carving was done.

Former homeowner Kay Schwartz, who commissioned the carving, also has quite the sense of humor. Since Hurricane Ike killed the tree and led to the carving, Kay jokingly nicknamed her mermaid "Tina" after Ike and Tina Turner.

The *Birds of Galveston* is located at 1512 Ball Avenue. Galveston is a bird-watching mecca, as many different bird species migrate through the area every spring. This carving features blue herons, an ibis, spoonbills, and night herons. There are 18 birds carved into this sycamore tree. All four species of birds featured in the carving can be found along coastal and marshy areas of the island.

In fact, birding is so popular that every April, the island hosts an event called Feather Fest, and Moody Gardens holds bird-watching classes at certain times of the year. This carving features some of Galveston's migratory birds. While most of the sculptures are carved into stumps, the majority of this sycamore tree was left standing, allowing Dayle to carve these herons into one of the branches.

In addition to carving the branches, Dayle also carved in the trunk all the way around. Here is another heron.

The *Guitar* is located at 1415 Ball Avenue. Although this carving was roughed out by Dayle, it was not carved by him. In fact, it was not even carved by a professional. This is Galveston's lone work completed by an amateur tree carver.

This carving was done by the homeowner himself. He wanted to try carving a tree with a chainsaw, and he succeeded with this guitar in his front yard. He even saved a few bucks in the process.

Three
Carvings by Jim Phillips

Artist Jim Phillips hails from Houston, Texas. Born the fifth of six children to a Scotch-Irish father and an Italian mother, he arrived in 1957 during the same week the Russians launched the first satellite, Sputnik. Jim never had much formal art training, just his mother, who taught him to draw as a child, and his junior high and high school art teachers. After taking a 30-year hiatus from art, Jim was cutting down a tree and began "doodling" on the trunk with a chainsaw. A recognizable form emerged from the trunk, amazing Jim and creating a magical experience he still enjoys today. Soon after he began wood carving, Jim's pieces were selected for display in several art shows, and he began selling works at the Simply Art Gallery in Galveston. Unfortunately, Simply Art was a casualty of Hurricane Ike and never reopened after the storm. As the city started the process of cutting down the trees that were killed by the hurricane's saltwater storm surge, Jim traveled to Galveston to collect some of the wood from the dead trees. While in town, he heard of Donna Leibbert's idea to carve some of the dead trees into sculptures. As a result, Jim was commissioned to carve the first pieces in Galveston (the fire hydrant and Dalmatian). Private homeowners also commissioned Jim, and the Galveston tree carvings becoming a huge hit and tourist attraction. Newspaper and television stories on the tree carvings have given Jim ample opportunity to continue carving. Jim's tree carvings can be found throughout Texas, including Galveston, Houston, El Lago, Missouri City, Calvert, Santa Fe, Richmond, Fulshear, Baytown, College Station, Greenville, Arlington, Humble, and Montgomery. Studio pieces carved by Jim can be seen and purchased at the Rene Wiley Gallery in Galveston and on Jim's website, inshoresculpture.com.

This fire hydrant sculpture is located at 823 Twenty-fifth Street. The first fire hydrants were installed in Galveston in 1884, and one of the early ones stands in front of the Central Fire Station next to the tree carvings. Behind the hydrant is a memorial commemorating Galveston's fallen firefighters. The Galveston Fire Department is the first and oldest professional fire department in Texas.

In 1841, wardens were appointed for five segments of the city to watch and warn of fires. The first volunteer fire company was the Hook and Ladder Company No. 1. Founded in 1843, it is located at 2308 Post Office Avenue. After a downtown fire on Strand Street, the fire department became professional and starting getting paid in September 1885. Two months later, a great fire struck on Friday, November 13, 1885. It burned for five hours, destroyed 568 homes in 42 blocks, caused $1.5 million in damage, and left 3,000 people homeless. Insufficient water pressure and the breakdown of the two steamers contributed to the devastation.

The fire companies originally were volunteer, but the city starting paying its firefighters in September 1885. The sculpture at right of a fire hydrant spewing water was the first tree carving in Galveston.

Seen here is a close-up view of the badge carved into the back of the oak tree.

This Dalmatian is located at 823 Twenty-fifth Street. Today, Dalmatians are merely firehouse mascots, but over a century ago, they were vital to firefighting. The use of Dalmatians goes back to the horse-and-wagon days. The dogs would run out of the station when the alarm sounded, and their barking would warn bystanders to get out to the way of the oncoming fire wagon. The dogs would then run alongside the wagon down the street to the fire, where they served a dual purpose.

First, horses are afraid of fire, and the Dalmatians distracted and comforted the larger animals as they pulled the wagon closer to the blaze. Second, the dogs guarded the wagon, making sure no one stole the firefighters' belongings, equipment, or horses.

The *Train Engineer* and *Signal Switch* are located at 201 Twenty-fifth Street. These two carvings stand in the parking lot across the street from the Galveston Railroad Museum. The museum was relocated after Hurricane Ike to Shearn Moody Plaza in what used to be the Santa Fe Station.

The museum is one of the five largest train museums in the United States. It features Pullman Palace cars, engines, and cabooses. It also served as the Fort Worth train station in the television movie *Gambler V: Playing for Keeps* starring Kenny Rogers.

Galveston Shore Life is located at 5701 Avenue S 1/2. This sculpture is one of only a handful carved into a still-living tree. It represents many animals found in the waters around Galveston. At the bottom of the tree are a crab, a school of fish, and a hammerhead shark.

Crane, Pelican Diving into a School of Fish, located at 20 South Shore Drive, is another sculpture carved into a still-living tree. Once again, this carving has a Galveston theme. People can watch pelicans dive into the water all over Galveston.

The sculpture is carved into a branch that died. The pelican on the left is diving into the school of fish, and the crane is on the right. Since only the branch died, Jim was able to carve the fish along the branch and have enough to work at the end to carve the pelican.

In this close-up view, the crane appears to be getting ready to take flight. Cranes are another bird that call Galveston home at least part of the year. They can be found in the marshy areas on the island along with herons, ibis, and spoonbills.

The *Galveston Totem Pole* is located at 1923 Sealy Avenue. The Case family moved to Galveston from Michigan when they retired, and this carving is in memory of the homeowner's late husband, R.D. Case. The totem pole represents everything Mr. Case loved about the island. From bottom to top, the carving consists of a crab, a seashell, a fish, a sea turtle, and a pelican.

The *Geisha* is another carving located at Donna Leibbert's 1717 Ball Avenue home, carved from an oak tree that died after Hurricane Ike. Japan is one of Donna's favorite places, and she traveled there on a number of occasions.

She collected many souvenirs on her trips, but most were unfortunately lost of when Hurricane Ike flooded her house. As a reminder of her Japanese travels, Donna had a geisha carved so that it faced west, looking toward the direction of Japan.

The *Tin Man and Toto* is located at 1702 Winnie Avenue. On February 8, 1894, film director King Wallis Vidor was born in the home where the carving stands. His mother was Katie Lee Wallis Vidor, and his father, Charles Shelton Vidor (for whom the lumber town of Vidor, Texas, was named), was a lumber producer and merchant with headquarters in Galveston.

Vidor survived the Great Hurricane of 1900. Just five years old at the time, he fell asleep on a wet mattress during the storm. He grew up and became a movie director, and his 67-year career led to his entry in *The Guinness Book of World Records* for longest career as a film director.

49

Vidor's credits include *Hurricane in Galveston*, *The Big Parade*, *Duel in the Sun*, *The Crowd*, and *Hallelujah*. In 1939, while directing *The Wizard of Oz*, director Victor Fleming was forced to leave the production to replace director George Cukor on *Gone with the Wind*. Vidor was assigned by the studio to finish filming of *The Wizard of Oz*—the parts directed by Vidor were the black-and-white Kansas scenes, including Judy Garland singing "Somewhere Over the Rainbow."

Vidor remained uncredited in the film, and he did not take public credit for his contributions until after the death of Fleming in 1947. The homeowners honored Vidor with a carving of the Tin Man and Toto, who is holding the oil can and making sure the Tin Man does not rust. The final credits rolled for King Vidor on November 1, 1982, when his life ended at the age of 88.

The Broken Column is located at 1028 Winnie Avenue, the home of former Galveston mayor Joe Jaworski. Jaworski served as mayor from 2010 through 2012, and his grandfather Leon Jaworski served as the second Watergate special prosecutor.

Following the death of this massive oak, Joe's wife, Rebecca, was not sure that she wanted the stump carved until she saw a picture of a memorial commemorating the victims of the 1900 Hurricane in a historical pamphlet. The memorial consisted of a broken Greek column. In any type of burial monument or memorial, a broken column is symbolic of a life cut short.

Since Joe's oak tree and the rest of Galveston's oaks had their lives cut short by Hurricane Ike, the carving is in memoriam of the island's lost oaks.

Where Have All the Flowers Gone is located at 1016 Church Avenue. This is another sculpture carved into a still-living tree. Hurricane Ike only killed half of this Japanese yew.

This carving consists of hibiscus flowers, sand dollars, and seashells, as shown beautifully in this up-close photograph.

Venus on a Half Shell is located at 1823 Avenue L. It is a freestanding carving that has been placed on a stump.

54

While the carving is different from the painting, *Venus on a Half Shell* is inspired by Botticelli's 1486 *The Birth of Venus*. (Courtesy of Library of Congress Prints and Photographs Division.)

The *Hermit Crab* is located at 1423 Church Avenue. Not only can hermit crabs be found on the beaches of Galveston, they have also become popular pets for residents of the island.

Many people have childhood memories of catching hermit crabs at the beach, and some of those people bring their children to the beach to do the same.

The *Pelican Holding a Fish* is located at 1609 Post Office Avenue. Contrary to popular belief, pelicans do not store fish in their pouches. The pouch is just used to catch the fish, which the bird swallows immediately. At Katie's Seafood Market at Pier 19, the workers occasionally feed the pelicans leftover fish, which is fun to watch.

The *Angel Cradling a Bunny* is located at 1701 Post Office Avenue, behind the Victorian Bed & Breakfast Inn. It is carved from a sycamore tree that died in the Hurricane Ike storm surge. Marcy Hanson, the proprietor of the Victorian, decided on an angel to honor the tree.

The angel is cradling a bunny because Marcy opened a bunny sanctuary behind the Victorian to help out the Galveston Humane Society. It is only fitting that Marcy rescues bunnies because she is associated with the most famous bunny of all: the Playboy Bunny. Marcy was a *Playboy* centerfold—Miss October 1978.

Four

Carvings by Earl Jones

Earl Jones is a native Galvestonian artist. Born in 1957, he graduated from Texas Southern University in Houston. While there, he earned a bachelor of fine arts degree in interdisciplinary art. Earl is skilled in clay, stone, and metal, and he is also an experienced painter in oil and acrylic. However, Earl is best known for his Galveston tree carvings. Inspired as a young child, Earl has been a devoted artist since the age of six. He incorporates messages of hope, love, and peace in his work. Many of Earl's tree carvings include dolphins, which he sees on an everyday basis at his job at the Galveston-Bolivar ferry landing. His favorite sculpture he carved is of Jack Johnson; Earl thought it an honor to carve a fellow Galvestonian for the citizens of Galveston. Also, there is a natural, heart-shaped anomaly in the wood that shows up on the carving's chest. Earl tried to obscure it but could not. Another of his favorites is the mermaid and dolphins carved into a camphor tree. The tools Earl uses to carve the trees include a chainsaw, a Dremel, a chisel, and a belt sander. To date, Earl has been commissioned for more than 20 carvings. He has also carved trees in the surrounding area, including League City, Hitchcock, and Dickinson. One of his latest projects involved carving a 50- to 60-foot fallen pine tree into an alligator. The carving is the Dickinson High School class of 2014's gift to the school. Of course, the school mascot is an alligator.

The *Dolphin* is located at 828 Ball Avenue. While carving the pod of dolphins across the street, Earl surprised the boy of this home with a dolphin carving of his own.

The carving originally stood in the fence line on the side of the house. However, the stump began to suffer from water rot, so the carving was removed, repaired, and placed on a post in front of the home.

Flock of Pelicans is located at 3227 Avenue N 1/2. People can see flocks of pelicans just about anywhere over the Gulf of Mexico or Galveston Bay. One of their favorite hangouts is along the harbor.

There, the pelicans can hope for an easy meal from one of the returning fishing boats or shrimp boats. Another popular pelican hangout is near Katie's Seafood Market on Pier 19. Not only do the birds try to get free lunch here, but they are also near the party boats as fishermen return with their catch.

The *Mermaid and Dolphin* is located at 4524 Avenue P 1/2. Earl is known for his dolphin carvings, and he has carved a couple of mermaids, including this one holding an open clamshell.

This is a view of the back of the carving where the dolphin is visible. Being that Galveston is an island, mermaids are also a popular theme with the carvings. Occasionally, folks can spot a mermaid (or a woman dressed as one) around town, especially during one of the local art walks that take place every six weeks.

The *Angel and Lambs* is found at 1124 Thirty-seventh Street on the Grace Episcopal Church property, a fitting location for this religious-themed carving. Grace Episcopal, which can be seen in the background, was established in 1876. After the 1900 Great Storm, the church was raised four and a half feet to help save it from future flooding.

The *Lighthouse* stands at 4017 Avenue M 1/2. The lighthouse is an island and coastal theme. Lighthouses have been used for the thousands of years, with the most famous being the Lighthouse of Alexandria, one of the seven wonders of the ancient world. The lighthouse at Bolivar Point was a shelter for many during the 1900 Great Storm. Lighthouse keepers Harry and Virginia Claiborne sheltered more than 120 people from the storm until the floodwaters receded.

While the closest lighthouse today is on the Bolivar Peninsula, Galveston used to have a lighthouse on the jetty at the entrance of Galveston Bay, which is known as Bolivar Roads. Lighthouses act as beacons and as safety devices, alerting sailors when they are getting close to shore.

Another one of Earl's famous dolphin carvings is located at 4017 Avenue M 1/2. It is not hard to find dolphins in Galveston; there is a significant population that lives in Galveston bay. To see dolphins, visitors can take a Historic Harbor Tour and Dolphin Watch or a free ferry ride. Dolphins are also known to swim along ships, like the tall ship *Elissa*, as they come and go from the bay.

The *Lion King* is located at 4510 Avenue L. This carving is named after the Disney movie. While there may not be any lions in Galveston, this one is the king of the island.

These blue herons are located at 1512 Ball Avenue. Once again, blue herons are a popular subject for carving. They are one of Galveston's most abundant birds. The carving includes a heron at the bottom and another one at the top that is about to take flight. Good bird-watching locations include Apffel Park on the east end of the island and Galveston Island State Park on the west end.

Here is a closer look at the standing heron. Blue herons are expert fishers. They either walk slowing stalking the fish or stand for long periods of time waiting for fish to come to them.

Here is a closer look at the heron about to take flight. When in Galveston, one should be on the lookout for these wonderful birds. They can be found along the coastline, in marshes, or on the banks of ponds.

Alligators and Pelican is located at 709 Thirteenth Street. The homeowners hail from Louisiana, so they decided to commission a carving based on a swamp scene. The current homeowners also participate in decorating their carving for holidays such as Halloween and Christmas.

Galveston is not known for alligators, but a few can be found on the west end of the island, where there are some freshwater marshes. Alligators are now so numerous in Texas that, like in Louisiana, there is an alligator-hunting season.

Alligator, located at 1508 Twenty-ninth Street, is not a tree stump, but rather a piece of wood. The carving, of course, is painted to look more realistic.

SpongeBob SquarePants, a carving of the children's cartoon character, is located at 1508 Twenty-ninth Street. Sponge Bob is popular with adults as well as children.

The *Dog Chasing the Cat with a Squirrel and Birds* is located at 1508 Twenty-ninth Street. This carving is also carved into a still-living tree. From the view at right, the cat, dog, and birds are visible in this everyday scene. Below is the other side; the squirrel is visible along with the back of the cat.

In His Hand is located at 4910 Avenue P 1/2. This tree had five branches that were then carved into five fingers, making for a giant hand. Isaiah 49:16 is carved around the wrist. The Bible verse reads as follows: "Behold, I have graven thee upon the palms of my hand."

Hand Clutching Diploma is located in Norris Wright Cuney Park at Ball Avenue and Forty-first Street. This is one of the city-commissioned park carvings. Born to a female slave in 1848, Norris Wright Cuney, whom the park is named after, became an African American civic leader, politician, businessman, and labor organizer in Galveston. Cuney served twice as a city alderman and was also responsible for securing African Americans the right to work as stevedores on the wharf.

The carving of the *Hand Clutching Diploma* is representative of Cuney's influence in the building of public schools for African American children. His greatest educational accomplishment was the establishment of Central High, the first African American high school in Texas, in 1885. Cuney truly believed knowledge is power.

The figurehead of the 1877 tall ship *Elissa* is re-created at 1409 Sealy Avenue. The 1877 tall ship *Elissa* is the official tall ship of Texas. Built in Aberdeen, Scotland, the *Elissa* called on the port of Galveston twice in its sailing career. After a 90-year commercial-sailing career and many modern upgrades, she was rescued from a salvage yard in Piraeus, Greece, by the Galveston Historical Foundation in 1975.

After several years and a massive restoration, the *Elissa* took sail as a three-masted bark in 1985. She still sails once a year during her Coast Guard inspection.

This carving is of the *Elissa*'s restored figurehead, which was modeled after local Galveston philanthropist Mary Moody Northen. Northen is the daughter of financial tycoon William Lewis Moody Jr., who, among many achievements, was the president of American National Insurance Company. She was a leading philanthropist at the Moody Foundation, which awards grants to various civic and environmental causes.

Born in Galveston on March 31, 1878, to former slaves, Jack Johnson gained fame as a professional boxer. Johnson's given name was John Arthur Johnson, but he went by "Jack" and was later nicknamed "the Galveston Giant." Johnson made his professional debut in Galveston on November 1, 1898, by knocking out Charley Brooks in the second round. (Left, courtesy of Library of Congress, Prints & Photographs Division.)

Following Johnson's victory, the search for a "Great White Hope" to dethrone Johnson began. This led to the "Fight of Century" on July 4, 1910, between Johnson and James Jeffries in Reno, Nevada. Johnson defeated Jeffries after 15 rounds when Jefferies's corner threw in the towel to prevent a knockout victory for Johnson.

Johnson broke a social taboo by consorting with white women. In fact, all three of his wives were white. As a result, he was arrested in 1912 for violating the Mann Act against "transporting women across state lines for immoral purposes." He was convicted in June 1913 and sentenced to a year and a day in prison. In the image above, Johnson and wife Etta pose in their winter coats. (Courtesy of Library of Congress, Prints & Photographs Division.)

On February 3, 1903, Johnson defeated Denver Ed Martin for the World Colored Heavyweight Championship. On December 26, 1908, Johnson bested reigning champion Tommy Burns in Sydney, Australia, to become the first black heavyweight champion.

Johnson went into exile to escape prison for his 1913 conviction, and he lost his title to Jess Willard on April 15, 1915, in Havana, Cuba. In the image, Jess Willard is standing over Jack Johnson as the referee does the three counts. Johnson returned to the United States and served his prison sentence from 1920 to 1921. (Courtesy of Library of Congress Prints and Photographs Division.)

Johnson died in a car crash on June 10, 1946. He was elected to the Boxing Hall of Fame in 1954 with a career record of 73-13-10. Along with the carving, Forty-first Street is also named Jack Johnson Boulevard, and Jack Johnson Park, featuring a historical marker and bronze statue of Johnson, is located at 1313 Twenty-sixth Street.

The *Pod of Dolphins and Mermaid* is located at 902 Ball Avenue. This sculpture is carved into a camphor tree that Hurricane Ike killed. These trees are native to China, Japan, Vietnam, Korea, and Taiwan. In Florida, the tree is considered an invasive species.

Camphor trees are grown for the oils found in their leaves. The trees also produce flowers in the spring and the black drupe fruit in the winter or summer. They can grow quite large too, as this one had when Ike killed it.

The mermaid blowing the conch shell represents the homeowner calling her children (represented by the dolphins) home. There is no preservative on the carving; that is the natural color of the wood.

The carving features more of Earl's famous dolphins. He signs most of his work, and his signature is visible here. He also left his business card carved into a stump to the right.

A private donor commissioned Earl for this carving. The donor told Earl to pick any tree he wanted to carve, and this is the tree he chose. That is probably why it is one of Earl's personal favorites.

Grandmother Reading to Her Grandchildren is located in Adoue Park at 1123 Winnie Avenue. This one of the four parks the city commissioned a carving for. The carvings in the parks were paid for by the Galveston Island Tree Conservancy through donations. This sculpture was carved out of a white oak that was planted at Adoue Park after the 1900 storm.

The story is coming to life above the grandmother and the children. The characters Earl carved are Humpty Dumpty, a pirate, the Cheshire Cat from *Alice in Wonderland*, the old lady who lived in a shoe, and an Arabian horse.

Earl also carved a bench into a stump so people could read to their children by the carving. The bench consists of a flower and butterfly. It is carved from a smaller tree that stood next to the bigger one.

From the other side of the bench, the entire butterfly is visible. Earl hopes people use the bench as intended and bring their children to the park to read stories to them.

The carving honors Fannie Kempner Adoue, for whom the park is named. One of Fannie's favorite pastimes was reading to her grandchildren, and the carving reflects the importance of learning to read. From the back, the dedication is visible. Fannie was the daughter of Harris Kempner, who built Galveston's first skyscraper in 1923–1925.

It is hard to imagine that the beauty displayed by Galveston's many tree carvings could have been created from such tragedy. Picture here are the devastating floodwaters of Hurricane Ike.

DISCOVER THOUSANDS OF LOCAL HISTORY BOOKS
FEATURING MILLIONS OF VINTAGE IMAGES

Arcadia Publishing, the leading local history publisher in the United States, is committed to making history accessible and meaningful through publishing books that celebrate and preserve the heritage of America's people and places.

Find more books like this at
www.arcadiapublishing.com

Search for your hometown history, your old stomping grounds, and even your favorite sports team.

Consistent with our mission to preserve history on a local level, this book was printed in South Carolina on American-made paper and manufactured entirely in the United States. Products carrying the accredited Forest Stewardship Council (FSC) label are printed on 100 percent FSC-certified paper.

MADE IN THE USA